Midwest by Northeast by Southwest

Copyright © Denise Weaver Ross, 2013
ISBN: 978-1482795073

No part of this publication may be re-sold, hired out, reproduced, stored in a retrieval system, or transmitted, in any form or by any means without the prior permission in writing of the author.

*For my children, Alex and Nick,
who have made this journey
worth the struggle.*

Preface

These drawings and poems play with the images that swim in memory about particular places. While divided into the three main regions where I have lived, the works do not provide a sequential narrative. They reflect my experience of the places where I have lived and visited and revisited. However, a short timeline of my geographical wanderings might be helpful.

1957-1960	St. Paul and Crookston, Minnesota
1960-1968	Milwaukee, Wisconsin
1968-1975	Oconomowoc, Wisconsin
Summer of 1975	Grants, New Mexico
1975-1979	Wheaton College, Illinois (B.A. in Art and Literature)
Summer of 1979	Lake Hubert, Minnesota
1979-1980	Chicago, Illinois (Edgewater)
1980-1983	UNM Amherst, Massachusetts (M.F.A. in Art)
1983-1986	Boston, Massachusetts (Allston) (where I met my husband from Jamaica)
1986-1996	Brockton, Massachusetts (where I had my two children)
1996-present	Albuquerque, New Mexico (where my husband died in 2001)

~ Denise Weaver Ross

Midwest by Northeast by Southwest

I headed off in three directions:
from my Edgewater apartment,
three stories up in a Chicago tenement.

Warnings aside, I pushed northeast to Amherst,
Boston, and Albuquerque via Jamaica.

While another self chose to stay,
taking classes at the Art Institute and a lover.

Yet another ran away to the mountains,
a mile high in Denver, broken hearted and lonely.

Now, thirty years later, I'm in Albuquerque,
meeting myself for breakfast burritos and coffee
at the Frontier Restaurant on Central Avenue.

Midwest

Waking the Morning
(and laying it to rest again)

I woke up in the morning on my third birthday,
singing the sun into the sandalwood attic
of my grandparents' parsonage in Oconomowoc,
Wisconsin, until it had bounced me out of bed
and rolled me downstairs to breakfast.

Sometime later that day, small household objects
– a thimble, a spool of thread, and a spoon –
were sighted bobbing along behind me in time
to my tuneless singing-a-song sing-song.

By noon I had also sung into levity
my grandmother's red-as-a-tomato pin cushion,
several of my grandfather's lemon drops, and
my great-grandfather's horn-rimmed trifocals.

*(My great-grandmother was tickled to death
to see her husband's glasses irreverently
turning a jig on the Sabbath day.)*

At that, my father put me to bed for the rest
of the day, praying my sing-songing to sleep
as the thimble slowly turned the corner and
left the room, followed by the red-as-a-tomato
pin cushion, seven lemon drops, and a spool
of thread; as the spoon fell silently to the floor
and the trifocals took roost in their cross-stitched case.

*(My great-grandfather, just home from church,
was shocked to find his wife rising from the dead
and irreverently turning a jig on the Sabbath day.)*

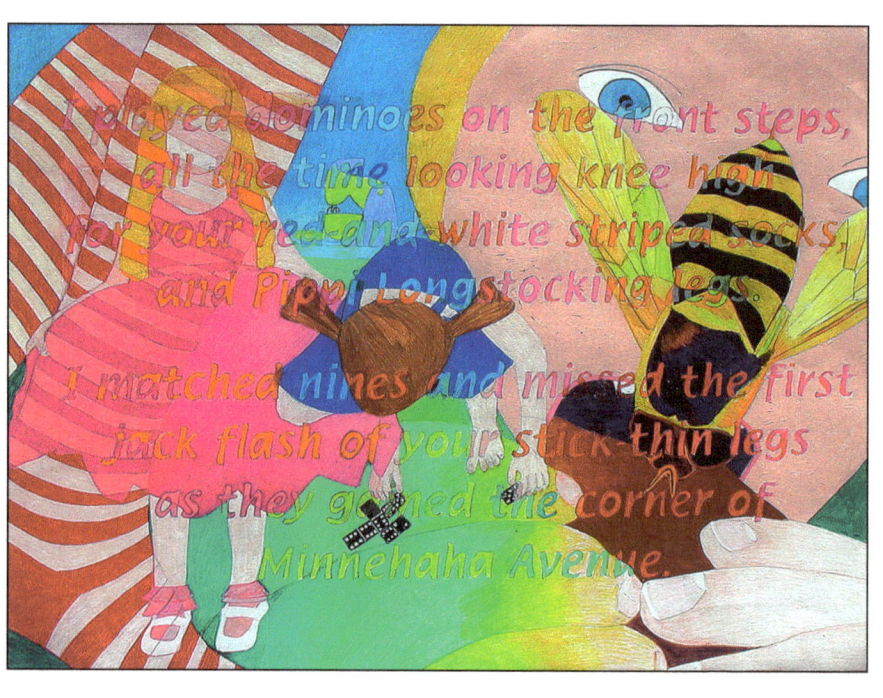

Minnehaha Avenue

I played dominoes on the front steps,
all the time looking knee high
for your red-and-white striped socks,
and Pippi Longstocking legs.

I matched nines and missed the first
jack flash of your stick-thin legs
as they gained the corner of
Minnehaha Avenue.

My frilly little girl friends
giggle-giggled at the conjuration
of my bespectacled,
bean-pole sister.

Especially Betsy, from kitty-corner
across the street with three tiers
of starched flounces and the *complete*
Betty-Homemaker kitchen,

And the tomboy sister
of the boy-next-door, who, while
showing his weenie and eating
a peanut-butter-and-jelly sandwich,
swallowed a bee.

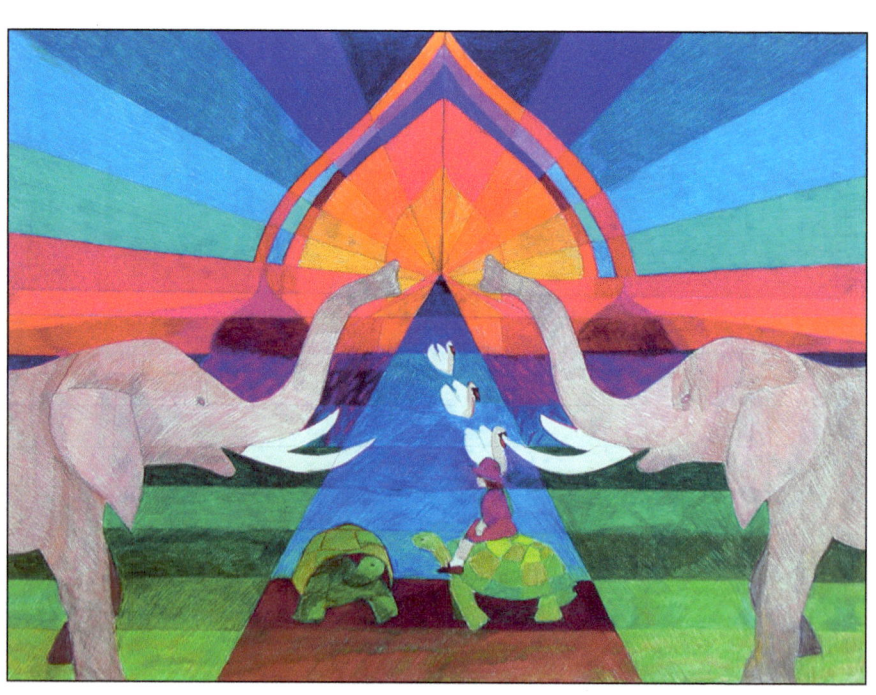

Arriving India ...

In St. Paul's Como Park
two giant turtles move slowly
across the slate floor of the greenhouse.
Perched on the back of one
of the lumbering creatures sits
a small girl, legs akimbo.

She imagines she is in the heart
of India; the cement walls of the foyer
are enormous elephant hides.
Their metallic trunks spray
across the length of the the glass jungle
as they move slowly into the shade
away from the summer's heat.

Outside the jungle, she watches
as families promenade past
the British gardens with the stately swans.
The Monkey House is the Taj Mahal
and Kubla Khan is just around the corner
when she is lifted high as an elephant's
eye and is swept back to the car.

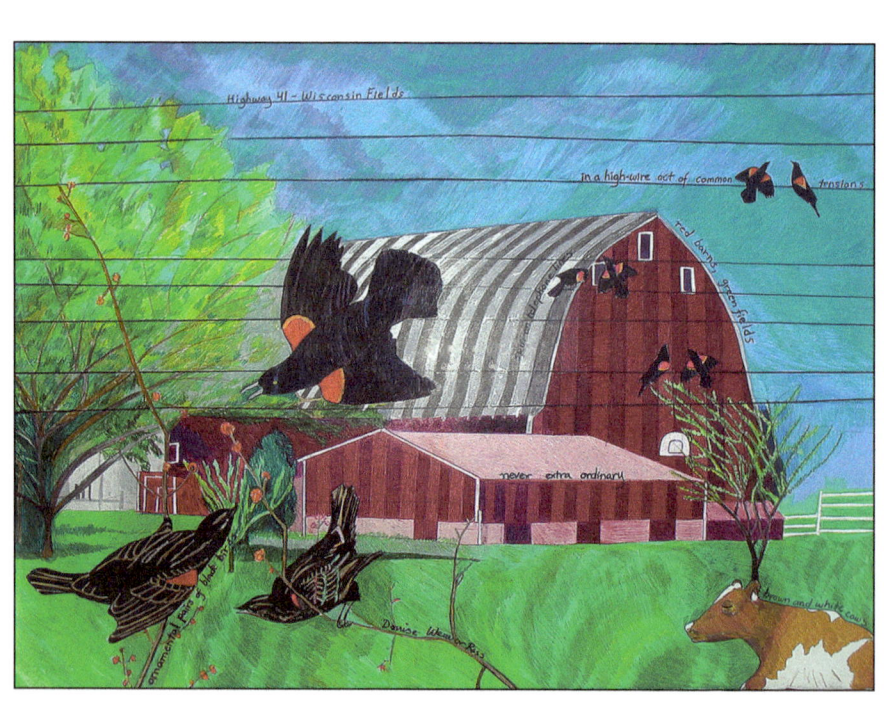

Wisconsin Highway 41

Red barns, green fields,
brown and white cows.
Ornamental pairs
of red-winged black birds
spin in a high-wire act
of common tensions,
never *extra* ordinary.

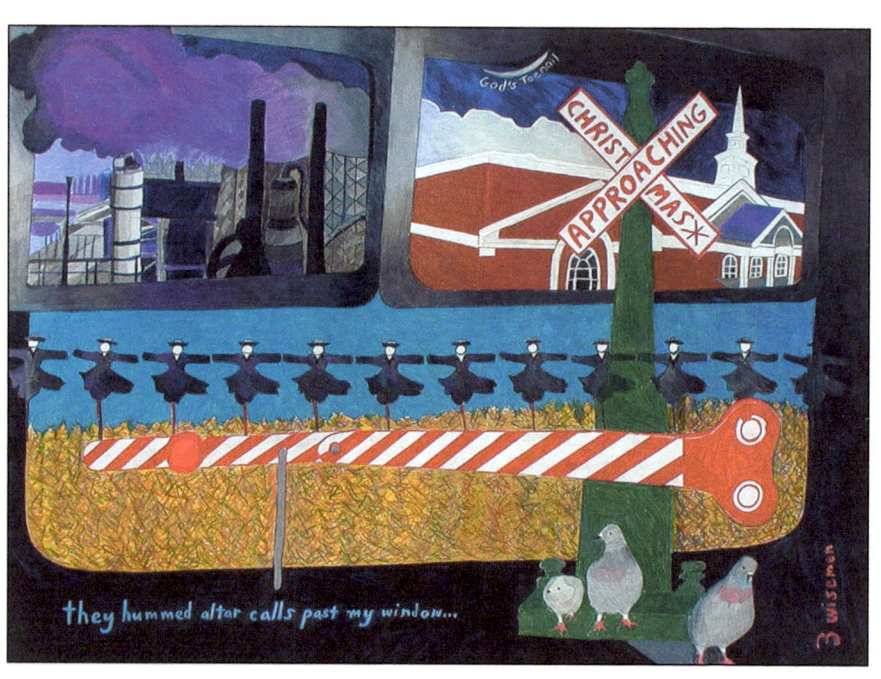

Approaching Christmas

I.
While riding between Ohio cornfields,
I noticed twelve gospel choruses in black shiny suits
curtsying like scarecrows.

I thought of you as they hummed altar calls
past my window.

II.
Later, when the black clouds of Gary turned white
over Hammond, Indiana, I looked for God.

Out here, he lives in the sky.
The moon is his right toenail suspended
like the Christmas star in the Sunday school pageant.

III.
I'm home now,
and three black pigeons are cooing
outside my window.

I think I'll invite them in.
Maybe they're the wise men come to call.

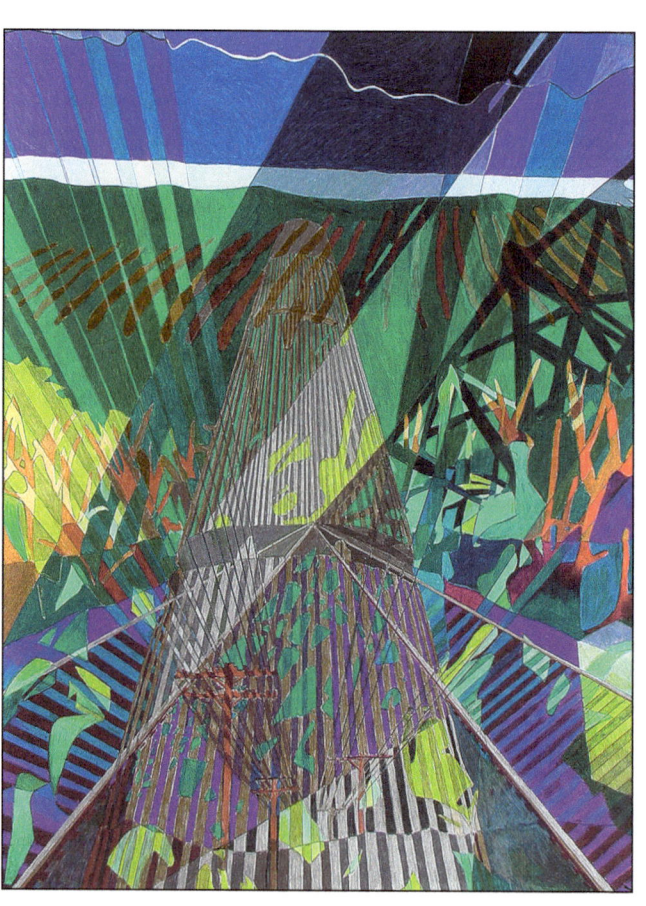

Lakeshore Limited

Dancing
through green
corn fields,
telephone poles
and viaducts,
the train pulls out
leaving rows
of silver tracks.

Northeast

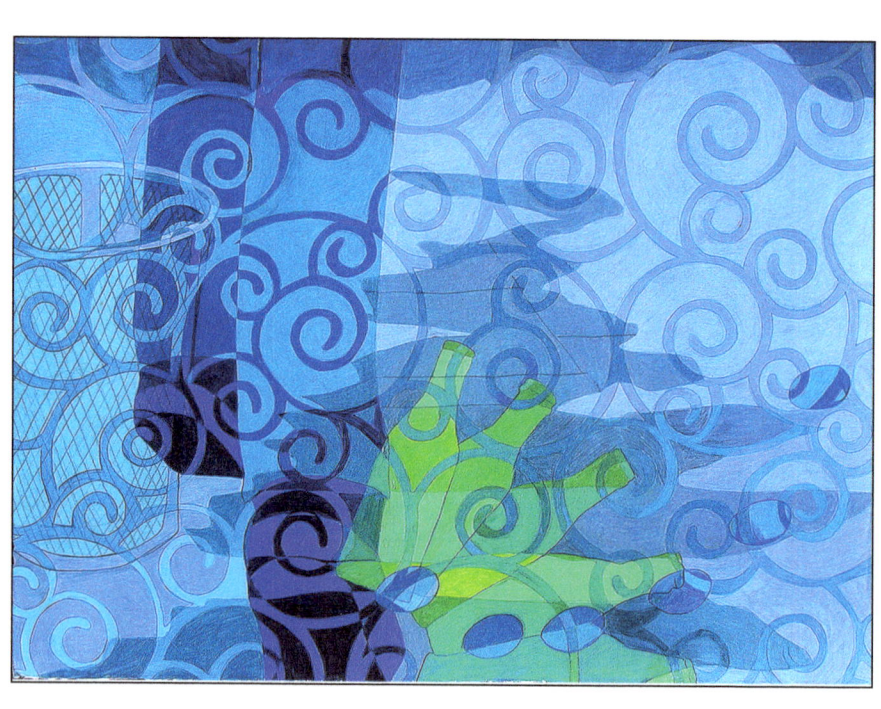

Amherst Arabesque

The street curves up
towards Triangle
and down to Main.

Curbs remain solid.
Bottles tip and roll.
New snow compresses
underneath my boots.

A stone arcs and spins,
tracing an arabesque.

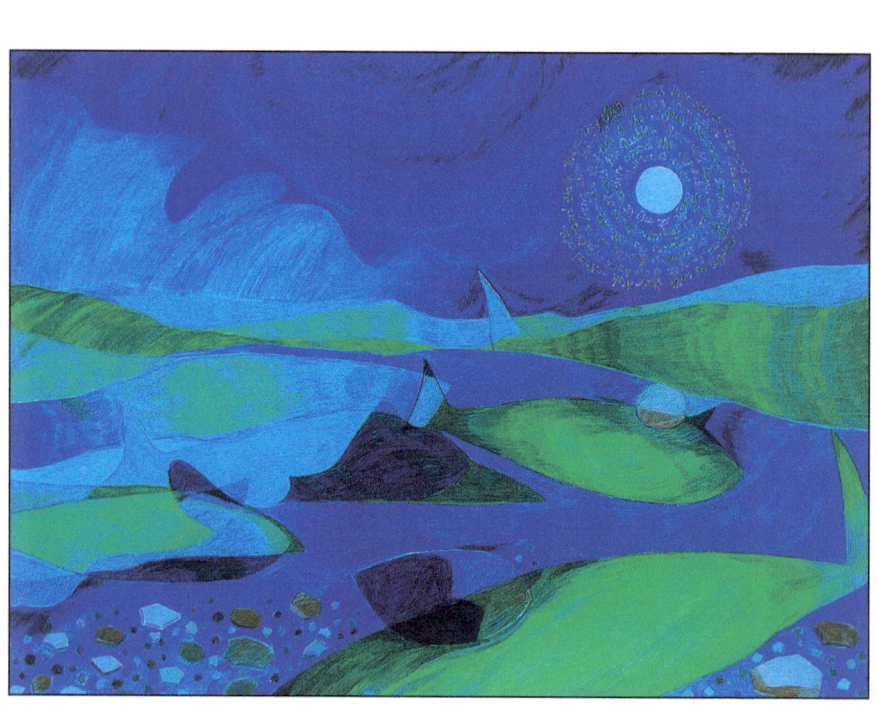

Quabbin Reservoir

Memories come adrift at night
which spend the day submerged
as forgotten towns beneath
the Quabbin Reservoir:
Dana, Enfield, Greenwich, Prescott.

At night, they rise to the surface,
like rounded green hilltops
or strandings of pilot whales
losing their bearings and
beaching themselves on Cape Cod.

Once aground, in spite of heroic
efforts to lead them out to sea,
they rebeach themselves
over and over again haunting
us with their high-pitched cries.

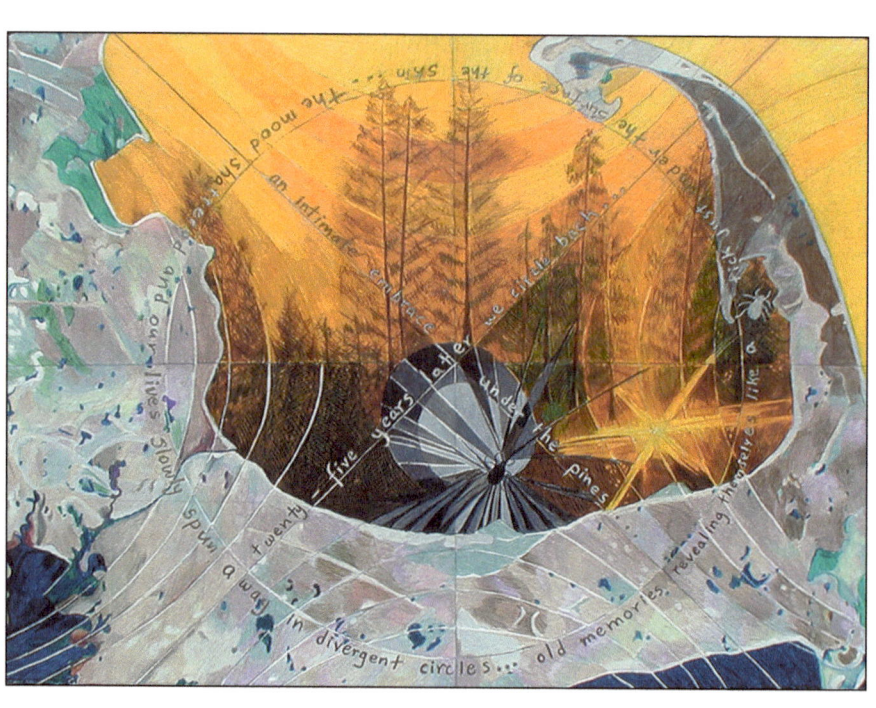

Ticks

While sitting with friends at Wellfleet Harbor,
a tick crawls up the underside of the bill
of my white baseball cap.

I hand my hat to you for inspection.
Examining it with a clinical eye,
you name the genus and species.

My mind flashes back to a submerged memory
of an intimate embrace under the pines
at Lake Hubert, Minnesota.

We emerged covered with ticks,
the mood shattered, and our lives
slowly spun away in divergent circles.

Twenty-five years later, we circle back
into proximity, old memories revealing themselves
like a tick just under the surface of the skin.

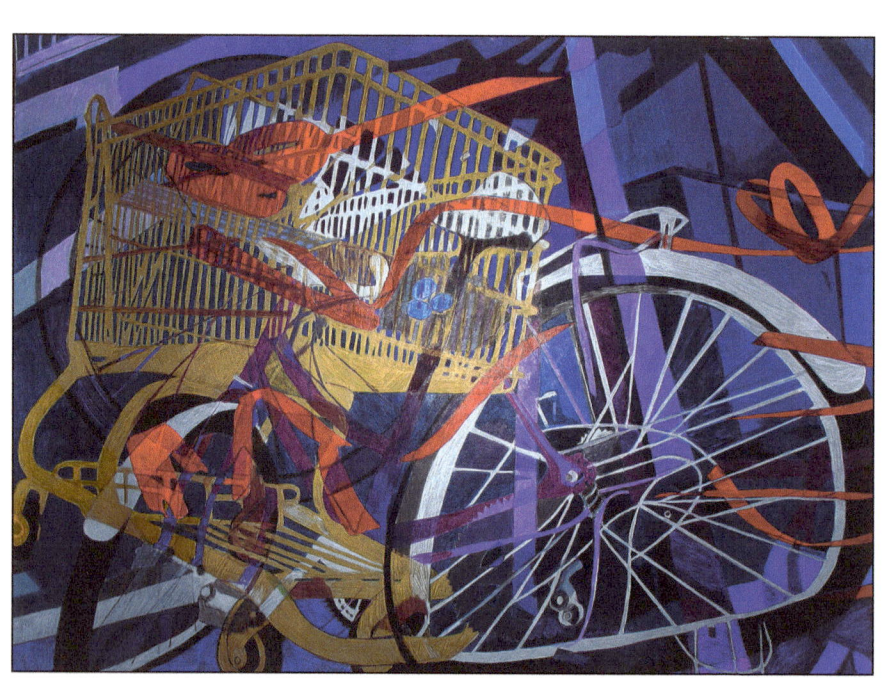

Allston Ragout

A wheel's spokes lie torn from the rim.
The lame body twisted, junkyard art.
The busted gears betray a fractured grin.

Handlebar tape, like royal ribbons, mark
a lost page turned by the wind. Empty carts
line the littered path like bannerless chariots.
Bent baskets make thrushes' nests.

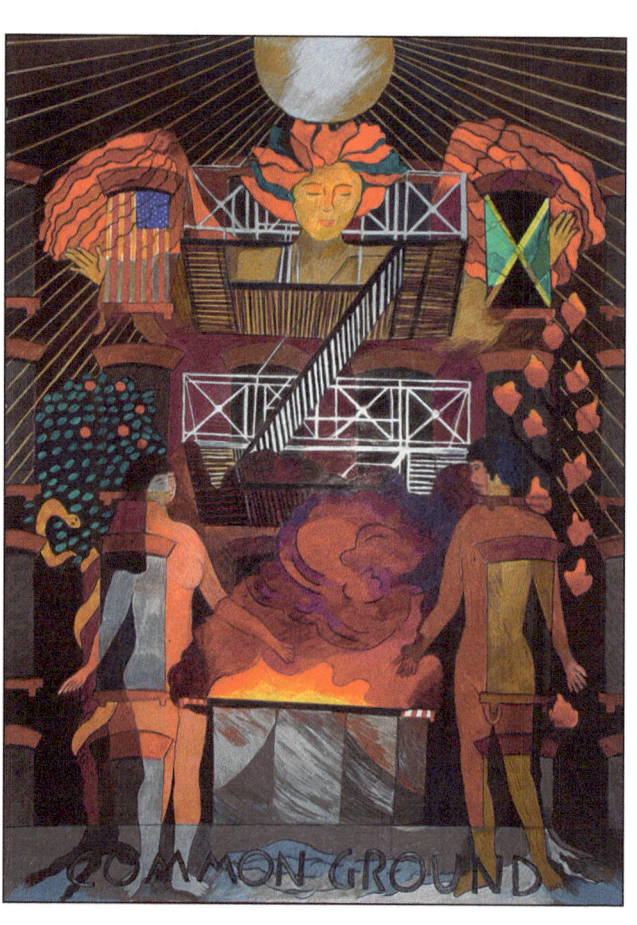

All Hallows Eve

It was your sister's birthday and
that old black magic was playing
with a heavy Carribean back beat.

We sang old gospel songs
and country ballads while eating
curry goat and rice from your
mother's kitchen.

I made you mint tea, Wisconsin
cheese and bread and gave you
an old winter jacket.

Later as we watched the bonfire
blaze in the dumpster
behind the Allston tenement,
we found common ground.

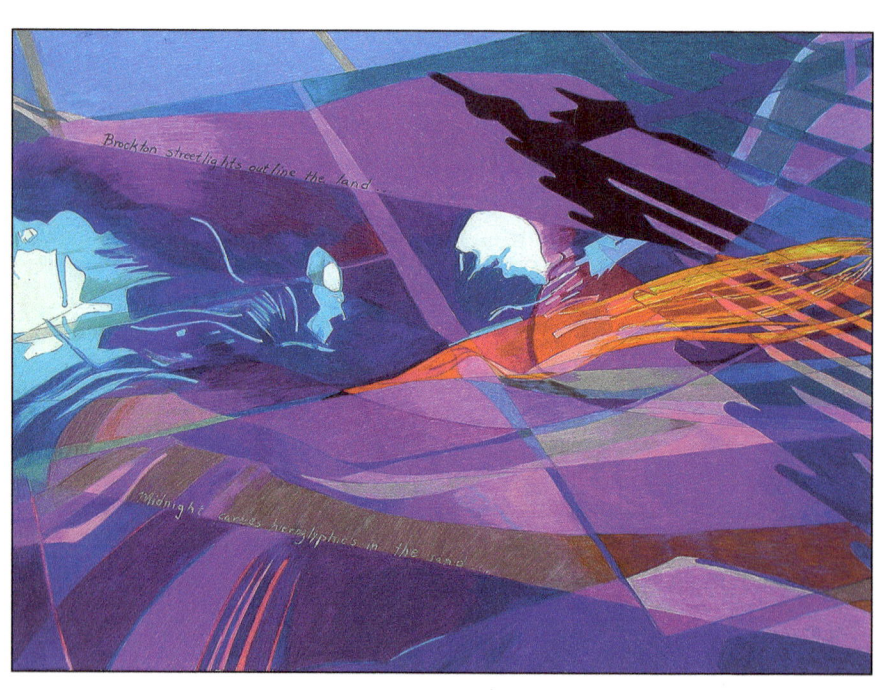

Desert Dreams

Midnight carves hieroglyphics in the sand
as the desert stares in an empty song.

Brockton streetlights outline the land
that runs beside the sheets and turns along
the edges of mirror, table and chair.
Bands of carbeams flash their tunes.

Deserts dreams vanish, we retreat to the town
where our feet crack sidewalks and a child
breaks her mother's back

Southwest

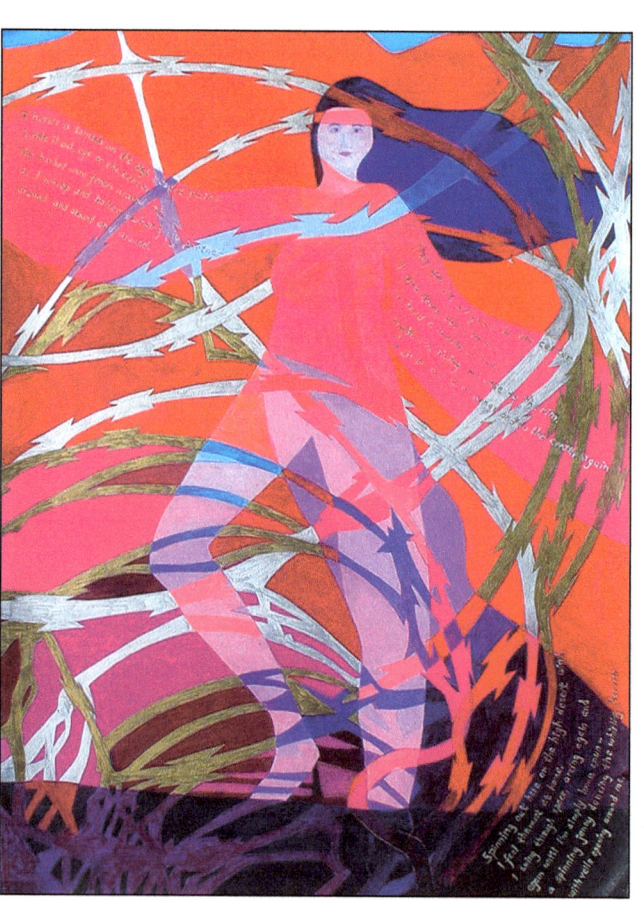

Spinning Jenny

There's a tornado on the high desert plains.
I ride it out, eye on the center.
The barbed wire fences around me
as I whoop and holler, swinging my partner
around and around and around.

They say it's all quiet in the center.
I don't know, but I reckon
I've heard a rumble or two.
Maybe I'm riding too close to the rim.
I circle out to my corner and to the center again.

Spinning out here on the high desert wind,
I feel the most at home.
I swing through space, arcing again and
again until I'm simply homespun –
a spinning jenny dancing the whirling dervish
with veils opening around me.

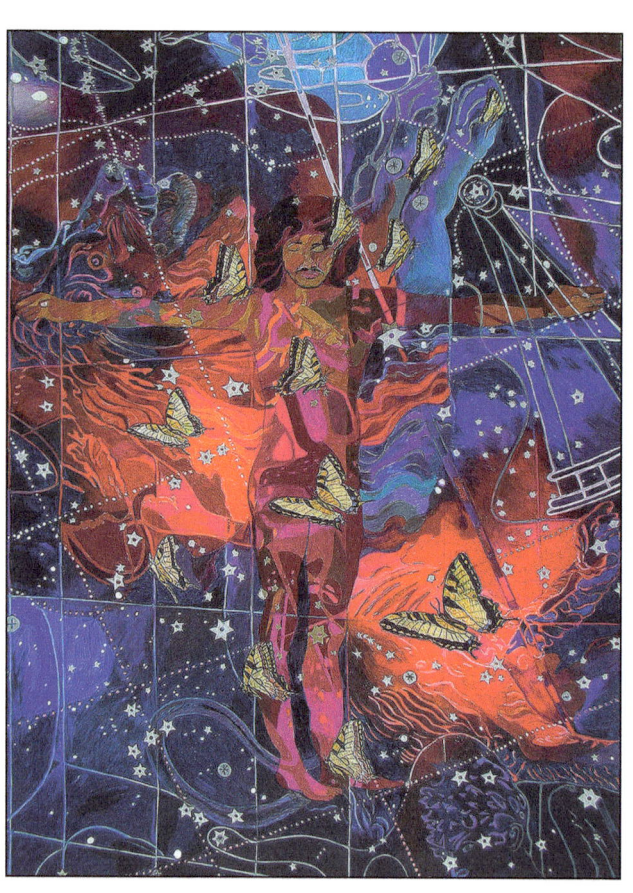

A Life... Suspended

You turned your head,
closed you eyes and, with a final sigh,
released a yellow swallowtail butterfly,
which multiplied in the sun
and filled the New Mexico sky.

I imagine you now, suspended
in wonder, among the constellations
of the Milky Way with swallowtails
spiraling around you.

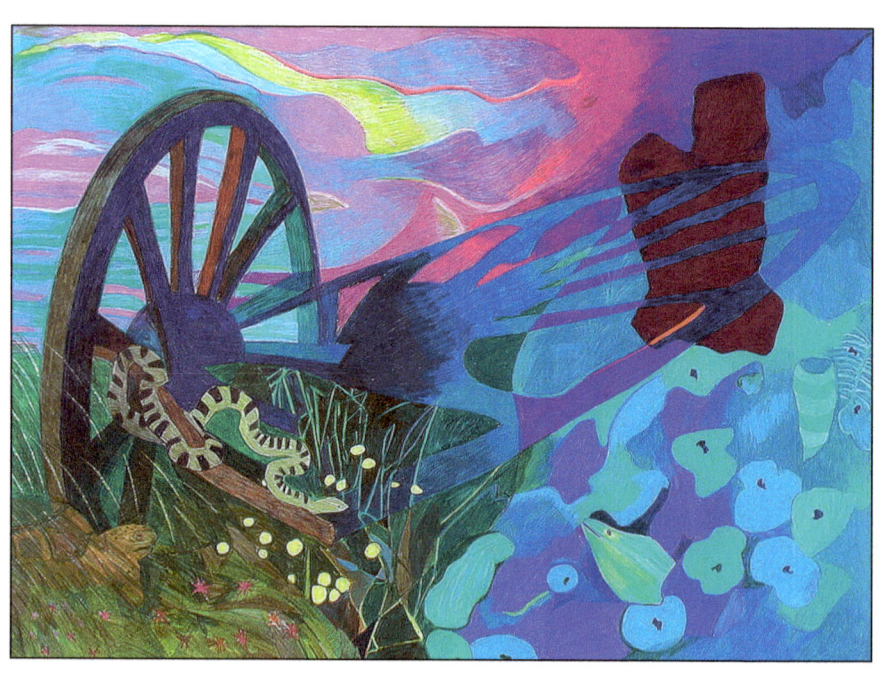

Revisiting the Wreck

Shadows spill across the sands of Cimarron,
cast by the ruined wheel of a prairie schooner.

As spectral winds whistle through the canyon,
the wheel shades a gopher snake, a desert
tortoise, and wild desert plants.

Like a ruined ship where eels poke
their heads out of the portholes
and barnacles grow on the broken hull,
life takes hold in the shelter of a wreck.

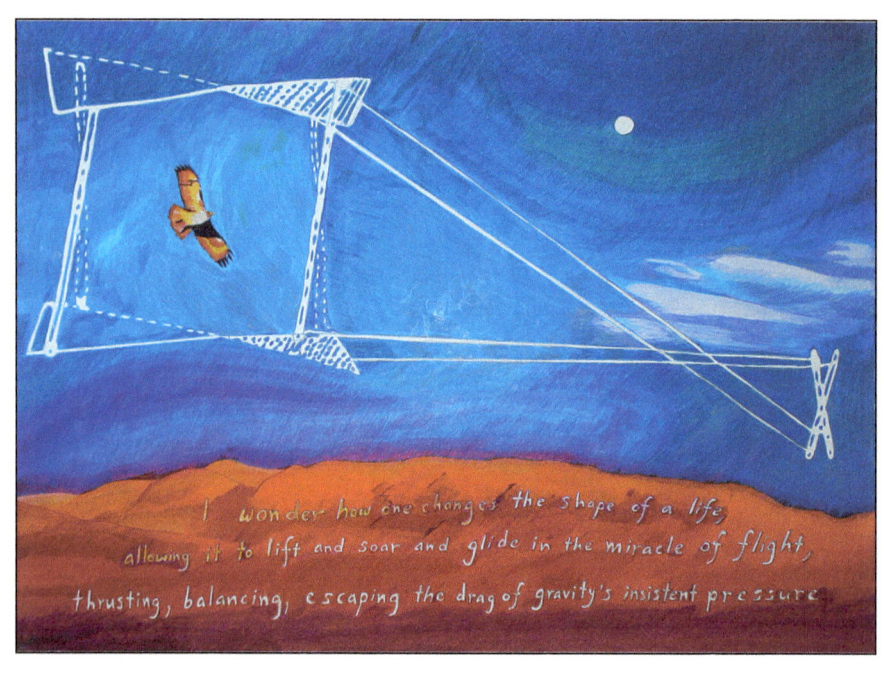

The Problem of Lift

I've heard about how the Wright Brothers
got off the ground by changing the shape of a wing,
solving the problem of lift.

Watching a hawk soar above the Sandia Mountains,
I wonder how one changes the shape of a life,
allowing it to lift and soar and glide
in the miracle of flight,

Thrusting, balancing, escaping the drag
of gravity's insistent pressure.

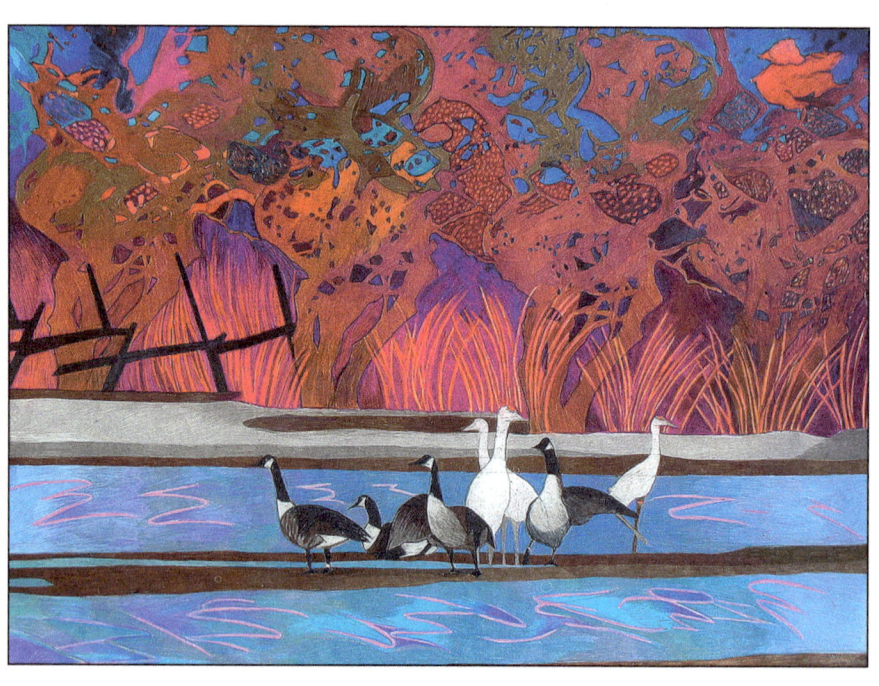

Drought

The winter has been so mild
that the Canadian geese have never left
Albuquerque for their haven in Socorro.

The cottonwoods cling to the last
of their drying bronze leaves,
rustling in trees like wind chimes.

The river is rapidly receding,
and the geese tuck up their long legs
to avoid running aground.

Soon tiring of the effort,
they float over to the sand bar
and stand like whooping cranes.

I fear they may soon have to wallow
in the mud like pigs to cool off
before they work their way north,
barely escaping the spring fires.

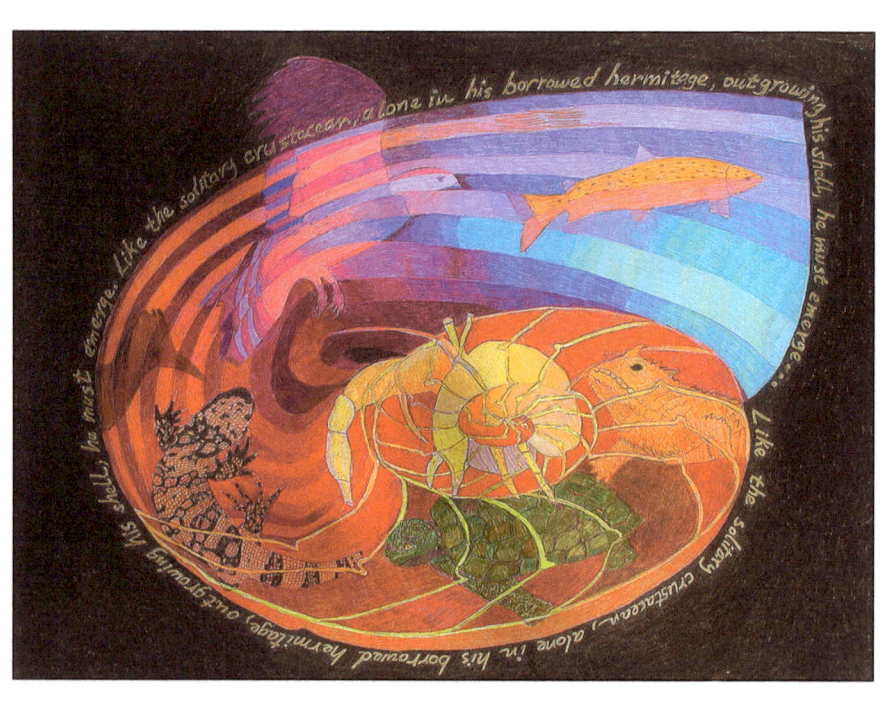

The Walk-In

Like the solitary crustacean,
alone in her borrowed hermitage,
outgrowing her shell, she must emerge.

Emerging onto the white sands of the Chihuahuan desert
to escape predators, she transforms into a horned toad,
a desert tortoise, and a Gila monster,
and begins her cold-blooded march to the sea.

Crossing the plains of St. Augustin,
the Sonoran desert and the Sierra mountains;
endangered by roadrunners, hawks, the border patrol,
she finds a home on the Baja peninsula.

Unable to rest, she changes once again.
Now a Pacific salmon, her journey continues upstream.

www.ingramcontent.com/pod-product-compliance
Lightning Source LLC
Chambersburg PA
CBHW041110180526
45172CB00001B/192